SPATE
A NAVIGATIONAL THEORY OF NETWORKS

EDUARDO NAVAS

DEEP POCKETS #1

For Annie, Oscar,
and Oliver.

Deep Pockets #1
Spate: A Navigational Theory of Networks

Author: Eduardo Navas
Editorial support: Miriam Rasch
Design: Léna Robin & Leonieke van Dipten
EPUB development: Leonieke van Dipten
Printer: Print on Demand
Publisher: Institute of Network Cultures,
Amsterdam, 2016
ISBN: 978-94-92302-11-3

Contact
Institute of Network Cultures
Phone: +31 20 5951865
Email: info@networkcultures.org
Web: http://www.networkcultures.org

This publication is available through various print on demand services.
EPUB and PDF editions of this publication are freely downloadable from our website:
www.networkcultures.org/publications/#deeppockets

This publication is licensed under the Creative Commons Attribution-NonCommercial-NoDerivatives
4.0 International (CC BY-NC-SA 4.0).

PART I TEXT CLUSTER	7
PART II I TREND	17
PART III YOU SEARCH	31
PART IV IT FLOWS	45
PART V SPATE MESSAGING	59
AFTERWORD APPROPRIATING TWITTER'S COMPRESSION	73

//Declare a thing, a person, a subject position, a situation:
var Text;

PART I
TEXT CLUSTER

A text's paradoxical power is its need of modest material production to come about, and a massive infrastructure to make itself relevant beyond its localized state. Trending plays a crucial role in this equation. Trending thrives on nothing but tripping on the meaning of meaning, for sake's sake, for speculation on speculation – for the deferment of actual signification in the large number of analyses as recognized in data-gathering and its manipulation as objective statements of future potential; as both cultural production and revenue for investors of global markets. Trending is emptiness presented as fulfillment.

Text cluster

Trending and data are best friends. They are one, they are it, they are this very text being accessed on an electronic device while its reading becomes logged on a database in order to be evaluated for future trends. For this reason, its flow can flip to a previous state of navigation, to the absurd and find itself typing on a piece of bread – while trying to capture the crumbs before they fall to the ground. But the crumbs never fall; they are kept afloat by a steady light breeze, which eventually is recognized as a humming that at first resembles the sound of the quick stapling of thumbs.

It's a bird.

A hummingbird could be the optimal symbol for the rate of exchange between flows and trends. The bird's wing-flapping of fifty times per second is certainly not fast enough for the current networks; therefore the bird only

functions as an aestheticized icon, meant to represent the 'innocent' efficiency of trends.

Flowing turns reflective when it's able to claim some distance from trending. Its immediate gratification is always slower than the last breath one will take. It always sits well with irony. When flowing, a statement is always true until it's discovered; its redemption lies in getting lost. Flowing and trending find the need for the self to come forth in order to let disconnected phrases and words appear with license for communication.

> *Encounter: Delete.*
> *[re]convene [de]centralization of [de]film.*
> *Shot.*

Flowing and trending recur, that's how they are acknowledged – repetition is the echo of representation. Their relation inevitably opens the orifice previously omitted by the confined liability of multiplicities: legion is still here after all. Sentimentality is dismissed by a trend. The flow of trends allows for the terms to claim a space waiting to be filled with hollow metal pillows in the center of a field of dreams that sucks dry the north region of knowledge, furnished with minimalist chairs, which are secured with nails made of foam.

Trending redefines obsession based on this type of reality, which is meant to be recalled with smooth memories of a time that passes seamlessly as the remembrance of an imagined future understood in terms of the past: trending is validated by the flow of past to future. It is defined by the recall of forgetting – for what is better than to present that which is already familiar as the new? This is the

prime element that drives the recyclability of all things material and immaterial in a time of constant flows. Clinical philosophy adds up to green arrows crossing the POV of politics, meaning they enable the possibility for sensitive stoicism: a mashup that compels the [non]believer to be [un]comfortable.

Trending once it's optimized for networks becomes one with flow. Trending flows, and one sees cats everywhere, next to rocks made of gray dreams converging with a tabulating machine which does not count but produces green bow-ties for which people have killed, and continue to kill. Green (not red) recurs as a color of violence, particularly when linked with economic value – as the free flow of global exchange under one currency that overruns all others. Trending once it flows, no longer needs to wonder but execute – all based on speculation.

Trending once it flows becomes the color of trust, the color of music, the color of life, the color of the unwise exercise of wisdom. Trending becomes the purpose behind a pen and a paper, a modem and a plate of fish. Trending makes selectivity biased. But once it flows it must also negotiate its navigation across data-fields based on its most formidable partner, which could also be its nemesis: search.

The drive to search is bound with the drive to flow. In order to flow, one must search, and in order for trends to come about search must allow for its flowing to turn viral. To be reflective on this, one could search for objection within the objective as one's objective. But this is an ever-increasing challenge because the apparent detachment, the apparent formality of the algorithm can no longer be perceived with critical distance: interpretation absorbs

exegesis as the speed of flow across networks goes faster than the hummingbird's flapping.

Reflectiveness may demand unexpected tripping on lead-saturated summaries of critical theory. A possible result is a misdirected search that may be more like gliding across in-depth rants about the relevance of ink on paper, only to find oneself floating on coconut saturated white mud, constantly looking to the right, hoping to understand what is on the left. One may hide in [b]rackets.

> *[a]-ly-[on] can be fierce with[out] the brackets*
> *[re]run-[re]turn-[de]tour-[de]stable-[un]done-*
> *[un]claim-[pre]negate-[pre]empt*

Cookies help search evaluate the status of branding info; in effect, privacy and media can be fully worked by developers and analysts. Search treats all data the same, it's in the way the algorithm is optimized to present some material as more relevant than other where the cultural and political aspects in need of critique arise. Search will present disparate elements jointly, as long as they are related based on shared metadata. A broad approach can lead to a rich recombination, including, but not limited to insatiable cravings for lard and milk, brittled-plastic napkins (used for cleaning lead off the couch), fiber, wood, pens, slurpees, scratched paper, screens, and all things that eventually may amount to noise.

Search can lead to thousands of virtual aisles with things on sale (everything is now discounted, nothing is ever sold for the price on the tag). Flow and search lead to the settling of accounts with some of the most unexpected network brokers. One should not be surprised for having

to pay with feathered soundwaves for unlimited use of the open highway.

Searching, flowing and trending make innovative promises that show no practical purpose, but always appear full of potential, because trending validates the other two. This is why some day, circular squares may well become common exchange items for the obsession with need and necessity; as they already are the drives behind the flows of desire. But no matter how much the three may depend on each other, it is evident that the basics of action still stand, and that one is still obsessed with plastic and wood – two sides of the same coin: the conception of structures.

Search begins in the morning. 'Wake up and look out the window... that will be 20 bucks, thank you.' That's what a friend once said to me in a conversation about life in the big city – a place where efficiency is pushed to its limit with the concept of instant delivery, taking place as fast as the thought of wanting something – which is never fast enough. The current drive in trending is to bring a crisis based on a question which will need to be answered sooner than later, 'what will happen when one purchases something before wanting it?' The relation of flowing, trending and searching is defining a new field of speculative economics, pointing to a time when preemptive ideology becomes the driving force of the global markets. With trending, collaboration and invisible labor turn into an empty exercise to lose calories; with search, sentimentality – the very concept of sentiment is used in the name of apathy; and when all this flows, empathy turns into distanced sympathy as soon as the threshold pushes past skin-deep. To make sense of these relations, brackets on the [un]familiar appear, *[bee]n t[here] be[in]fore.*

The aesthetics of music, the repetition of sound becomes the means for emergence in the networks. One jacks to the sound of a keyboard, simulated for touch and for the sake of nostalgia – for it all resembles house music: 'House is a feeling.' Writing is a feeling validated by simulacra. Search leads to the expectation to experience the known for the first time, to experience the obvious for the first time. With search discovery of common sense and logic becomes naturalized – devoid of intellectual investment.

Trending depends on search to flow and go viral, but it also needs messaging for all this to happen. For messaging, compression is key. One can produce texts that say a lot or nothing, one can text a BFF about one's BBDS experience. Or just express the potentiality in meaninglessness with compressed statements such as 'of \|/ with the ‖ and the @# to come)(with %,' which is an euphemistic phrase about the future-cast of the stock market. Texting, as obsessive as it is, is also impersonal, which is why people may find the need to do it over and over again, maybe to find the person on the other side within an ever-increasing compressed repetition. Regardless, the result is systematics appearing to be similar to a welcome with no sentiment. Simulated keyboards can lead to poetic misunderstandings: 'six‖een][imes out of the |-|oky pok4s'.

So, there are four elements that currently drive networked communication: flowing, trending, searching, and messaging. All lead one to be compelled by ideology. They bring together demagoguery in social media to create a contention in tracking and data-mining. It all appears as air flowing across networks, when a search is performed in order to text and tweet, and make all that is searchable with the potential to go viral – for the sake of

trending. Flowing offers twisting turns on every corner of a nihilist experience; living the void to the fullest, one can hope for nothing but what will be lived differently. This is how a space is inhabited with the [im]possibility of the simulacra of silence. Here is the space of spaces trending; dependent on virality makes possible a real non-place to be experienced everywhere as nowhere. This is how the gear of nets was fully developed within networks of instability in order to provide its confirmation through negative existence. To keep up with the viral flowing of trending, storage became abstract and situated somewhere, and keeps shifting within rooms, towns, states, countries: a limbo bound to geographical spaces, but trying to find ways to be free of localities – trying to turn location into an ephemeral state with low cost of movement. Trending for the sake of ever-expansion pushes for production based on strategies of dematerialization. Thus, how sad to think of modems and cables as [art]-i-ficial.

The constant flow of trending gone viral leads to landscapes that one cannot hope to visualize except in the mind.

> *A green-plastic-leaf dropped swiftly from*
> *the very top of the sky when the wind blew*
> *across the genetically-enhanced room with no walls.*

> *Swing. Static.*
> *Coo_ like a grown polyester stem*
> *struggling to keep moving straight.*

> *//I\\ won / der w[hat] s(he) w-as-/ w[ear]*ing.*

The paradox of searching, messaging and flowing is that they are symbiotic with trending based on a sense of selectivity that is optimized by quantitative, not qualitative production, though the latter is only possible as the backbone of the former. This leads to concepts of resistance, and opposites defining each other for the sake of coherence in the mind of rational subjects. This is the [un]seed of dialectics: The concept of silence – the concept to silence – the concept of [un]control. Adorn-[o] your mind with dialect-[i]-al thoughts about the aesthetics of negative-being as a state of critical production.

For flowing, the thickness of a book becomes an obsolete element in the experience of reading. Flatness becomes the norm across all material and immaterial elements produced; kind of a there-[ish]-ness behind the hidden exposure of social media. And so one may say to oneself, 'someday... I am going to know less about things, but it does not mean that I will forget'. Because data will sit there ready for access (assuming one does not forget how to access). Flowing, trending, searching, and messaging thrive and depend on sensory motor skills, particularly touch; a sense that is cognitively displaced, detached from embodiment's relation to incorporation consequently redefining the body as an extension of flowing networks. This helps all four elements convert ever-changing privacy into transparency and recursively redefine the status quo.

//Declare a thing, a person, a subject position, a situation:
var Text;
//The value can be passed to other variables:
//Text becomes personal:
var I = Text;

PART II
I TREND

An apple adopted a mouse in order to get around. The chance to run into the unknown at random has turned into a well-oiled algorithm of social value with empty circulation. A cable goes up the clouds and plugs into knowledge to extract selected resources for the sake of contentions and conflicts. A table made of cotton (I like cotton) firm as steel(y) dan[ish]. I scan the disk to find the anomalies.

I trend.

I'm the difference that always tells itself something about the norm. To wear or not to wear: that is the reflection on the mirror. Truth and logic run into danger when the subjective and the objective become flipped to develop complex systems of human relations.

My hood covers the metal head[ing] of over-saturated crumbs of overly-dry-pesticide. It's impossible not to make sense: once in the symbolic, I see all things within the clouds. A word recurs in me for a reason; evaluate the subjective as objective and vice versa: a plane, a bird, a tweet. I always fly in speech.

> *Dried, fried, tried, cried, plied, died*

Tons of clips on view upon the realization of my existence. The conundrum is to know what I should, could, would, and must know. How can I know what I'm missing if I haven't been exposed to that which I already desire? Don't talk to me about lack, or desire, nor jobs and fulfillment. Talk to me about the desire to lack *lack* itself as a means to the real – (no).

To edit is to know
what not to present
in order to show
what is not there
Furry towels met
the logo-centric guru
hidden behind emptiness

Furry fury meets
the facile retweet:
the foundation of going viral
Plastic, elastic, bombastic, shakalastic

The lens, the focus,
the analysis, speculation
fact-checked

Looking
through threaded
fibered-lenses

Focus on
the pattern's sameness
to notice its disruption

Dots, circles, lines, vectors
turned immaterial fetishes
Jacked to the sound of the algorithm

Hoods, hats in red

To say the same differently can be dangerously deceiving.
Critical reflection consists in knowing the difference
between the repetition of difference, and the difference

in repetition: the *i* in technology never looked more
suspicious. My investment in technology becomes a staple
after quantification provides a promising rate of return
based on well-informed speculation. Saturated grays are
the simulacra of black and white: a palette considered
colorless and full of cultural tension.

I get the same three in front of me. It must be that I clicked
on them to check 'em out – but did not follow through.
Suspenseful lines, exuding tension, mystery, and even
horror – thus the power of an open-ended fragment.
Allegory of open interpretation. The fragment and the
module are similar, but the former has autonomy byway
of multiple readings, and the latter autonomy as part of a
whole. Here and there and everywhere, non-places are the
spaces to inhabit. The myth of a tree growing straight over
one growing crooked has turned into an obsolete cliché of
[in]tegrity.

> *Space, mace, glace, taze, praise,*
> *place, pace, craze, maize*

I'm in a different place with the same setting – the screen,
hosting and posting the future of the history of the self,
huffing and puffing the meaning of the past. Meaning-
[less] as a [frame] work of stability is the result of semantic
engagement as a means to constant communication. What
happens to my past when my present looks to my future?
Mulch for ventures in the known of potentials. 2:55 is a
number linked to chronology, but its true potential lies
in its irrelevance to personal time; a hard, mad, happy
toaster meets a table midway to the answer of an open-
ended question. Flat is the new fiat. Change happens when
finding ways to work with streamlined strategies calling

for efficiency. Red is defined by subjective relevance of the sensibility of extremes, danger, love, hate, desire, communication – compromise.

My creative piece of a useless, purposeless, relentless cleaning instrument. Clean without a purpose: soap, someone said, is a key sign of civilization. It certainly redefined my individual relation to dirt. The self as the subject of analysis is the reflection of my obsession with pervasive mirrors within my over-guarded core-self. The fallacy of my stability is to define itself against speculative futures of static recursion. I keep getting the same three every time. I must not be as diverse as I thought. Why three, not two, one, four, five? Is it the old pyramid scheme?

Spacing | | | | | | |\|\///// \ \ | \\|| \ |\ | || \ Look | over| ||there|| [where] is enclosed within |when|: time and space are repositioned when the immaterial becomes the driving force behind the material.

The symbolic increases, strives to become absolute. Speculative economics are effectively producing millions with immateriality. Four squares within a square. Windows within windows – frames, and images what[e]-v-\er/s. I do one more to reach ten. It's no longer about quality, but about reaching the sky by pushing rock bottom. I thought I had ten. Play tricks on me. Keep me productive. Say nothing of the spinning iPhone that keeps me sane. Look, it stopped. Don't know karate, but I know crazy... been working hard to supersede that reference – the backbone of a long struggle. The backbeat rules. I'm about to go out to struggle with proper penetration: trying to find the balance between concrete and cotton.

Work, labor, pleasure, leisure are now pristinely mashed-up in holidays. I'm checking the numbers that lead to speculation; numerology with databases. Modes of exchange are not necessarily modes of communication. Persuasion of communication and communication of persuasion are at the crux of visionary speculation. My phone walked off the table to become a nomad, not satisfied it yearned and made contact with estranged devices of the Other.

Synthetic wood never looked better | Its shininess appears na ‖t|u‖ ral.

The metallic-fog covered the gorge, filling the entrance of fornication. Long and thin signifies elegance and its opposite: context takes full precedence in ephemeral instances of archived statements. Oh, it's been three, not two, not one. This is not a countdown, but a statement of production. I check the block in front of the thought. I dispel labor as the ideology of legitimation with action. Nothingness adds up to everything when acknowledged for being full of potential. Looking up to the top left from the corner of my eye, not a gesture of seduction, but of power when gender is undefinable.

What should I deliver but the [un]-self? Nesting media with development lingo: never before has innovation sounded so much like sci-fi. Future trending is real fiction. Getting two of three, and a new hackie. Oh well. Diversity appears in the horizon. Juxtaposition of ideas and things are considered the foundation of new ideas and things: the concept of originality came about inbetween. A testament to the view from below the sky, looking for the unknown to rediscover is familiar. To ask the same question

differently is dangerously misleading. The repetition of the same differently is not the repetition of difference.

Data d-ata d-a-ta da-ta da-t-a dat-a d-a-t-a d|ata d|a|ta da|ta da|t|a dat|a d|a|t|a [d]ata d[a]ta da[t]a dat[a] [d][a][t][a] Yes.

Spec[s] not spec[t].

Empty today.

Nothing.

I fetishize finished woodwork, plastics, synthetics: smooth surfaces are not shallow, but deep. Deep as a flatline signaling the absence of a pulse: it's been some time. How's it going? Here in the woods of synthetic fiber, I'm looking for bears in the clouds full of morphine, dreaming of a tomorrow that recycles itself. The big toe, full of truth, tells me lies in order to keep its integrity as a solid member in the balance of null procedures. Emptyness becomes an anti-existentialist obsession. Danger lurks in the romanticization of existence for critical conservativeness. Full = empty. Shallowness appears associated with self-fulfillment, and abstention is revered as the means towards safe nihilism. I find that stories written for kids always tell the truth about the imagination, while showing the process towards neurosis. Systematic randomness is not better than honest indulgence in form.

> *I. Sit. Up. Down. Side. Step. Left. Leave. Ever.*
>
> *Pants, chants, rants, skin against*
> *rust, glare coming through, thirst for lapsing*
> *friction among symbols of disproportion.*

Let's play a game of house. The house where the workers and the lords live with a veil of juxtaposition: mediated daily life made bearable; a broken wheel apparently functioning properly is the benign potential for reconsidering scarcity of resources in a non-sustainable reality.

Marisol showed up this morning… and Jesus shows distanced happiness. The third is irrelevant. Suggestions to follow become benign exercises. I'm looking out from a bleached-glass container only to realize that my inward view is consistent with expectations of sustainability. The change of color signals omission. Signals death: green to red to dry brownish-orange. I often speak, think, dream, and obsess about the body and technology in part because I'm framed in a dualistic relationship.

Faux-plywood is friendlier to the mouse. I'm missing things from the last few days. Could it be my mind or a data-glitch? Time flies. I thought I had been active a bit more. Wonder if some things have changed since I last jacked into the house. For some reason, I still get the sense that something is missing. And why does nothing show up the usual way? Does change really happen? I must live with the hunch. The basis for conflict and drama. The foundation for eventually receiving an Oscar. The concept of human greatness is limited. One must always praise the struggle of the self, even when displaced as preoccupation for the planet. I have a reflexive moment before finishing an over-caffeinated dark drink. A suppressant not a depressant: I must stay productive.

Homogeneity takes on a pervasive form. This is not my place. This is my space. This morning, while chatting up

my pants against Woolite, I got four legs and a landscape.
Why do I keep going back to sensitivity? What I crave may
already rely on the simulacrum of meta itself. Nature: a
river, a pipeline in contention. It's the flows of political
cognition at stake. Advertising as a personal social act
is dependent on a cookie that supports a brand's status.
My info and privacy become blogged-out: for sale. Green
objects in front. Red in back; white on one side, while
the other is open. The question is if it's left or right. I
purchased a long rectangle, shaped to sit, designed for
leisure, but meant to be used for labor: stretch the leggings
but not the legs, contemplate their potential. I keep
thinking of cookies and brands, a healthy diet of networks.
I help with terms. I share my privacy status: its non-
existence and its promising future.

> *Graphs, charts,*
> *and automobiles.*
> *Plains, planes, panes,*
> *stains, tainted grains.*

((Che\\ck |t|-he \ I /mag[o]e of a[n] /a/steroid ob-ss\\ess[ed]
eth-nic [o]. (o)-[O]-|o|-{O}

Dance is an action, a space, an environment. It's an
exercise of self-awareness – pushing the physicality of
concepts in political forms. One more for the road. How
deep should I go on the way out? Swiftness did not share
an intellectual space with rigor, until the time of networks.
I need to write something now because time is running
out. Deep thoughts run through my head, but appear to
disappear before they can become meaningful. Romantic.
Romantics: a pop group of the eighties, that's all. Looking
to the left I understand the right: I understand what is

not in order to be. The opposite of happiness is the very definition of existence if one is willing to find joy in the binary. Rhetorics never felt better.

Felt Felt – F|[e]|{l}|(t) the pad[ing] in my mouth while blowing rusted steel kisses to my lovely beasts of burden.

And then there were [n]one. The right to begin again finds itself in the self-righteous exercise of self-awareness: romanticize integrity. One more for the road. I'm told iron is good for my health, then make it sparkly only please. Check my Adidas painted on a drape. Trees on stress, waiting for precipitation: cycle of variable temperature is nothing but market correlations. I do the wrong thing for the right ethical question to attain an existential critically distanced outcome. My black socks never look dirty on a sunny day. I experience the rub of rubber. Green is talking about Red and Blue. White will show up soon.

En[gage]-d in T@l//ing round|a|bout mean\i\ng-less [r]-s-easons.

Toilet water tastes as good as the knowledge of its source. Tension in sexual advertising leads to violence of the ~un\-known. Red in historical context/s is the reposition of a Malevich in terms of formalism as a means to become immersed in the politics of distance. My no-cry Sleep [re]-solution: be productive and lose remorse for not meeting my goals. I let go of bananas, and eat the straws and berries. I miss the feeling of that which is not here now. Absence acknowledges presence: its negation. Existence recognized by its termination. Twisted thoughts of kindness leading to the righteous life of a being whose drive is symbolically indulged in understanding

incomprehension. Elements of wonder and the concept of discovery: how the colonial mind comes to define the other by means of territorial appropriation. Move fast.

s[hi]-t\\his -i-deal\\\i-zation as a w/\ay to[ward]s f -[uck]-ear. Kiss~\ed| t-[he sk]-y with[out] a[no\\ e-x`c#//use.

No-se[y] glands taking over the pipes of freedom. Feeling sick is not a metaphor when the sky eclipses the pavement. I keep up with the run-on commoditized sentences of nihilistic hope of a sober existence defined by saturated media events. A media-holic looks for a way out. No more eyes or ears; only smell is arguably the last sense that may have some romantic resistance. Raspy, tickles, the whiteness of impurity is at the front door. I open it to slam its negation: the affirmation of existence. The strongest come in threes, so 'they' say. Gossips of integrity meeting design principles are always appealing to the mind – any min[e]d. Two shoes, two legs, all in gray, neither black nor white. My ambiguity is the code not living up to its potential. S[lip]age of meaning is the over-played convention to communicate in an over-saturated symbolic world: to state it makes it more meaningless.

""\{h}e-re\Y? i[no] j[un-]g[glin]-gle. Pea-////nut[ty] un-i-ver[se]al g[f-oo]d is [n]o-r\t`~ con\\ass//umed. Feeling down.

Media is legion. No leader is the wolf-pack. A rack of goods: CDs, language, and tomatoes m[r]ake the perfect subject of conversation for artist[an]-s wit-ho-uter di[e]rection. Mary's sun is the name that keeps coming back to my mind, and when I tracked its locality I encountered a 69. I'm about to help on the terms of cook[ies]ing the pri-[m] va[velan]cy of a status app. A device is designed to flex its

muscle. No use, peruse, misuse, disuse leads to diverted flows of mediated techne. The wrinkles on a [u]natural surface appear smooth in comparison to the stretched melodrama of trend-economics. The inverted spiral once moved dialectically. The semantic parade flipped the script. Mining the mine of bits became a naturalized state. Non-linearity appears promising, perhaps because the linear is predictable.

Center to the left leads to the right. Taking a position is never a gray area. Political correctness is the demise of data-mined opinions. Re-pe[act]-ING the s[L]a/me, mov-e-[ing] th`r~ough cl[r]ou[l]wds. Sentimentality for coherence never attains a higher connotation than the reconstruction of what the subject meant in terms of the now. Don't compare apples and oranges I'm told. How is diversity to be measured? From a critical distance: How is diversity to be contemplated? Tracking the trace:

becoming == have become

has never been closer to [im]material reality than now.

[Con]-stant [up]-dat[e]s.

Bird feathers weigh heavily on the guiltless animated being: stoicism strives for ultimate detachment in the name of the [r]-[s]-eason machine.

The circular never catches up with future-casting. I just got surveyed: [sub]-ject[ified] by the brand of the little red tails. Pull on them and call the pork, I was told.

```
//Declare a thing, a person, a subject position, a situation:
    var Text;
//The value can be passed to other variables:
    //Text becomes personal:
        var I = Text;
    //I becomes another:
        var You = I;
```

PART III
YOU SEARCH

Promise me you'll sell me my own needs as desires and make me desire my own needs. To get lost was once presented as a means towards criticality: once you lose yourself, you will know the way. Blanket-wrinkles caress your thoughts as you make sense of the non-linear. Can you tell me where the wooden table went? Caring for your threaded thumb, caring for your thumb-sized love triangle, caring for your thumb-sized triangular love. ABC your dinos while chiding with the caring-candle-vigilant-beings outside the strip mall, tripping the stripped. Swipe your mind before and after every use.

You search.

The relation of your handwriting and typing exposes the contention of efficiency in an ever-increasing world driven by compression of all things. Fake wood is more natural than an honest answer: Lying reaffirms the truth based on negation only to move into a gray area. You are not excited? The potential of rusted ideas polished as a brand is the obsession of future-trending. 24/7 specs. You flip the script: house to the jacked sound of information overflow. Noise is controlled for the sake of our compromise called communication. Flip to the first; jack to the sound of overused eyeglasses lacking prescription, designed to make perfect vision appear unfashionable. The murals stored in the cloud become available on the screens of anyone willing to transgress experience as a virtual factor of lack. This is not your place, but a localized tweet. Refresh gives you, and everyone else, instant hope to experience something new; passive action becomes the foundation of a radical lifestyle.

You feel the flow through saturated-meadow-hairs. Flat-vectored flowers decorate the honeycomb of the dead. Life hungers for expansion of diaper pails. Red-covered rings of gold are worn by the AI techies living under the carpet of time. Sensitivity is negotiated with networked distance of persons who are so close that you smell their breathing... the collective smell. Three quarters of the way to what? Your goals are subjectively placed in order to support a sense of moving forward. You look to the ground to understand the sky; to know something by what it is not becomes a safe-haven of political-correctness; to discuss the meta of the meta is an empty exercise; sports, politics, economics all share the same entertainment template; an IPO opening is promoted as a sporting and political event; rolling downhill with an uphill attitude: another way of defining critical distance; sky-blue meets gray-blazing data manipulation, resulting in abstract reflection on the possibilities of the informational void. 333 is the number of production in front of you linked to days of disparate labor, fragmentized chronologically. You give in to the graph of objectivity to develop an interpretation. A priori is difficult to keep at bay.

The edge has become the center for innovation. Niches are the key to the infinite number crunching diversification. Global markets: check the goods, drop the bag, grab it all without gloves, the texture on the bare skin is virtually synthetic – clinically natural. Soap was mentioned here before. Once conventionalized, it became the symbol to rid yourself of the many [un]s, the noise opposing control. You poke and swallow; white paint on your chipped shoulder attains new meaning when dealt a full deck of saturated fat. Z means omit at this stage. To improvise in this case is to lose anything if the wrong turn is taken repeatedly.

Annoying and out.

f[a][i][u]n [wh]-\Y/ ou s-[aid][T]-hat.

Kleenex becomes a common noun referring to tissue: disposability eventually is transferred onto computing with planned obsolescence. Bitten things, battered things, representing the incompleteness of a statement. Your fragments become valuable for potential multiple readings; data-mining is the closest thing to mind-reading. It will be essential for a reality of pervasive future trending. Spirals overlap diagrams of lathered nonsense, not leading to a specific statement but speculative intellectualism – transcending academism.

You fuel the tank with quantity. Your empty action never meant as much as the mere act of typing at a specific time in a specific place. Sunny-bright-blinding-night turned to the tune of the blues; you feel as happy as an avatar could who believes in the choice to choose. Sex[y]-u-al space across the platforms of common exchange. Familiar venues of passage glare violently over your over-exposed eyes. Blazing statements overshadow the vectors, taking on flights of free exchange, while professing a negative stake for those who have little. A pen filled with questions waits to release its potential on a blank, flat and shallow surface; ink holds the potential for open statements. The possibility to conceive a move: a twitch is the ultimate hope for anyone looking for answers in looped questions.

You check the frills, the chills, and dills of the shop; the barber on the left and the mechanic on the right – the cheese sandwich upfront. What is the rhythm behind the [algo] presenting correlated knowledge on the periphery

of preemption? The signification of the hoody runs from protection to danger: within and with-[out] the body which wears it. A cup swiftly flipped released cartooned-pieces of hair, exuding good coffee. Search your phone for the name that fits a modern description, which escaped along with the feathers of your favorite pillows.

[F]-[p]-[c]-[m]-ases, [cr]azes, p-aces, p[r]aises, p [h]`r~ases.

The cent off is the scent of the drive for the black against the red in quarter earnings.

[W]hat a di[ver]ffer[g]ence a text makes. There they are again, but one of them is different because your traces show where you are. Anonymity is one thing that cannot be bought. Panopticism is no longer self-implemented by the subjects, but voluntarily exercised quantitatively to reassure order and normality as innovation. Somebody always knows. You b[c]ake the water into the spoon that lingers with no specific goal other than to become one with carpets of joy. Distance collapsed: beyond a cliché. Immediacy is the new norm[al]. Connectivity swiftly moved from desired innovation to necessity to survive. You check the goods, and notice one new suggestion on how to expand your [k]-n|h|-o-[w]-on-ledge on the wire. Respiratory ambitions, aspiratory position, contrarian pos-| ing |-tions. Sexy is the new carpet available at the corner store, which is always selling things not yet conceived.

Similarities in c-[re]-[der-iv] ative app[roach] at times app-[h]-ear too \c/-lose for n-[on]-com/fort. [Re]-in-\\flection[s] on a dam and aged l [if] e.

The grape on the vine waits to be defined as the division of class: labor and leisure. The elephant in your tub is unable to unplug: no need to call the plumber, who switched the mb into gb, and eventually into tb. The smooth blue surface challenges the orifice to stay hard; makes the vector expand beyond both. Don

for the [r]-[t]-ight position of pragmatism. The brand of writing transcends material commodity once flows are stable enough to guarantee constant updates elemental to economics. You got two new ones. What a treat, and you're only less than three days old. Just hovering over will guarantee perpetuation for a while (and affect loss). This is when AI may be useful to evaluate quantified activity. You're going in, regardless... There. OK. Now on to the clouds. Cybernetic gastronomy never tasted better. You're told it's secure. So show some skin... Why the suspense? It's all rhetorical. Empty statements full of truisms. Forgot the 'al' there. Unfollow feels like indirect rejection. Stress manifests itself every time a new one shows up.

s[t]-o-[me] on-ly[on] I a[m]-orning the bast[ion]ard of e\\ thic//-s[ic]-kick to m[wh]y stom[ache].

The hard drive on its side never looked better. Loops, repetition, recontextualization of information: data on a date [less] the love[less].

The brain comes together with ~/\|||||%#!***``~.

Noise appears detached of expression: a way out for the stoic. You are dry as a desert filled with lies not lie – nor the lied. Structured expression well measured is the best medicine for rejected success. Again implies repetition, but recollection is essential for a joke to function under such paradigm. It was good. It was really good. Como? A buca buca. Ugh, disgusting. Ay that was so high on the low. Running on a full bladder of Gap commercials makes you feel lighter on the jump. Inhale and indulge in the fuming plastics reconfigured as the new pressing against your left hand as you write yourself. More not mores: the

liability of knowing aphoristic thinking leans on quality
of quantitative altruistic decomposition. Suggestions,
recommendations are circular elements that redefine
the subject through repetition: variables of homogeneity
appear diverse. Biking, singing, and acting suggested
today: sexual violence objectified through affect-images
showing expression of what cannot be seen. The language
of business presents things as practical. 'It's not so
simple' you think: abstraction makes for simplification of
contention.

Gloomy.

Why can't reflection be more jubilant?
Why must it be serious?

Critical distance's own downfall is it does not know
when to chill. The boss, the man needs to be de-centra-
gendered... Rock-shaped buckets fill up with cold
liquid going up the nostrils of an electronic piped-up
organ; lubrication not needed. A statement is affected
by what is beyond the screen. A non-place does hold
on to abstract concepts. Your acknowledgement of a
glitch is the recognition of the possibility to move past
cognition, which is immediately lost. Your error is defined
by binaries, by secondness, not firstness... Here's the
issue. Right here, not there, or everywhere. You invoke
abstraction to search for a concrete state that may also
be considered a semantic riddle only to sound academic.
The void is not empty. The negative ultimately defines
the affirmative and vice versa. Issues of the binary arise.
You jump only to drop farther than desired. You release
the energy within the bellies of purple-tainted clouds
overloaded with personal data. Look[ing] at the |stat\s|

of thing[s]. All is approached with the same quantitative template.

You keep checking for syntax. The freedom of expression and its neurotic drive. Apples and bananas just hanging along with the wallet that made their commodifiable signification possible. Indulge in economics of health. What's happening you're asked. It's the ac[?]-t-|ion| as the means for constant flow that allows such a question to be t[s-he] drive[r] of life. Stripes/types/mikes of mice and means of de-generational sameness: hollow statements full of rhetoric. You eat the over-cooked plastic.

Your smile goes a long way – a vector that connects two points with an apparent universal, which breaks the distance of psyches. You open the extremities with a long thin device, and learn from their growing tension: observation is not to become indulgence nor indolence. Vectors penetrate the water source, while the fire continues its journey across the triangulated network of bugs and bits, bytes and bites. The squares behind the left ear never complemented better the eyes of your poodle. To speak of the now is to understand the n-[on] existence of abstract presence. To think of the future in terms of the past is to understand presence between the two: the negativity between both explains existence. You got recommendations to follow the BBC, a port and a retired surgeon telling jokes about the red pen that defined their intellect. Insulation results from compartmentalized thinking; privacy followed: the former thrives in modular aesthetics while the latter withers. Getting dirty never was more [un]-ethical: once the remote was introduced it was no longer necessary to wash guilt off your hands.

The self[ie] the ie in the green pastures of central
insecurities that drive the ideology of progress. Why an
ideology?... it is safe ground. The seasons remind you of
the recurrence of change. The obsession with a difference
that does not recur is a romantic lie. You're [un]-fascinated
by what shows up on your doorstep. It says more about
the quantification of psychology than the self. Sell at all
costs. Does a celebrity need to pay to be recommended
constantly? A search will answer that, so the question
is rhetorical. No. Dryness. Why not strive to gain the
most creases in all things? You take the skin to the brink
of bleeding, right to the threshold. Beauty. The first
name that does not sound like a constraint but does not
mean anything specific other than the most abstract of
aesthetics.

> *Landscape imagery*
> *Textiles*
> *hooked rugs*
> *Mane Wagner: the image of Christ*

Established terms when recontextualized/displaced/
stripped of basic signification appear meaningful for the
meaning of their ambiguity. Ludics should be in better
shape now that gaming is no longer about innocent play.
Collect material culture; make a career out of it. Love
the fetish with a critical distance in the name of good
taste. Take a sip now... Pat on the side of the belly, not the
top. Firm as a stone, love to bite the byte into bits: cobble
refined to become a mockery of the fake. Chaos and
modularity are closely linked: they define the possibilities
of speculative trending of networks. You debase
quantification: once in the [sym]-bo-[olean]-lic enjoy the
show of binaries. Drama is about extremes aestheticized

for self-indulgent collective reflection. The dilemma of critique is how to be honestly critical while being part of that which is critiqued. You push the [sub]-culture to its limit; one more for the sake of developers. In the name of quantity, you use the binary-cloth to wipe the characters left after the end of this phrase. Oh, there it is again. When recommendations become annoying it's time to move on to the next beta.

More info means let me know if this has potential within the realm of becoming *in potentia* of potentials. Ads and cookies recur in your mind:

re[bra]i[n]d the help-desk[top] n[on] oscillated realms of violence.

> *Beck, Kagan, Bak, Gale, Bourke,*
> *Citizen, Garrett, Daily, Broido, Fabian,*
> *Brooker, Perez, Yap, Disparition,*
> *Bucar, Fremont, Albino, Taller...*

The outline of a shape is the periphery that defines that which becomes the center of attention: let the birds eat the sun. [in]-[out]-[just]-[ice]: a system pays a major price for striving to present objectivity as its paradigm over the social context of events. The Swiftness of statements that define the body is cemented culturally in the architecture of the mind. A dog and cat sandwich a person who smiles over random recognitions of recommended signs of disabled locations. The 're' encapsulates contention of innovation:

[re]-cycle-play-organize-consider-view-post-blog-write-create an idea. O-[rig]-I-ni[h]-li-ty.

Feeling the blues; reflecting on the sordid vector
that presents the objective as a statement of truth[s].
Fun, gone, news. Pausal 69 is recommended. You got
Coco as one of three, but two remain the same.
You had a dream about crit\\i/ CA~li[for] ty [ni] A and
s[i]-e-n[si ‖yes‖]bill[y]-ties.

Noise does not have a single source, but at least two: it
comes about when things collide, come into conflict
– challenge each other. The need to constantly share
your opinion turns benign with the obsession to be
d-(is)-[own]-ed, which is most delicate when it involves
lives. Ephemerality of speech (its trace) once upon a
time resisted measurement. Mining of data opened the
potential of your re-cly[cle]-ever-ness. Keeping up with
the Joneses' amnesia, sometimes called art. The less you
know, the less I know: it's not better – it's just art-[tra]-ns-
[form]s.

Narcissism is encouraged if you type regularly. Its pattern
defines entire markets from black-Friday to life insurance
rates, among all other things.

//Declare a thing, a person, a subject position, a situation:
var Text;
//The value can be passed to other variables:
//Text becomes personal:
var I = Text;
//I becomes another:
var You = I;
//You becomes simultaneity:
var It = You;

PART IV
IT FLOWS

Not myself, nor yourself, nor herself, nor himself, nor ourselves, nor themselves. Just a self, any self, a transgendered self, a genderless self, a self of the selves for the selves, and by the selves – not one or multiple selves, but a legion of selves for the self, itself.

It flows.

It's a network eating nuts, perusing scanners on the run, pursuing reversed egos, pushing sound on the red – exploring the threshold of noise. It's fingers in a bowl, places out of range, a distance from the eye and the leg, near the pen and the typographic self.

It's the symbolism of a stop sign in a windowless desert. Legion: chilling to the sound of wheels standing still, while noticing a palm tree arching over its oppositional image longing for the deaf acknowledgment of its own foundation. It's the recurring posthypnotic state of delusion, a slogan: 'Insipid time is the drive of happiness'. Bullets of electric-current cold as metal napkins are shot on the side of a liquid square, missing a statement, while keeping an oath, and making mistakes. Memory forgets:

1. Keep the glass, lose transparency, experience light behind reprinted concrete
2. Ground and hand built as one in the quest for texture
3. The hypocrisy of distance, the instability of intimacy, the normality of dim lights
4. Sweetness, grids, and the stubborn collective
5. Spend time in the center
6. Milk diets: half empty, half full

It rides a coaster midway to an open-ended answer for an open-ended question: the wind slaps with the sharpness of a rake; flat algorithms pronounce themselves as wrinkled awareness of depersonalized contempt, awakened at the speed of modular despair. It's a sensorial vacation in a safe that is protected by a time control device, which bookmarks the mid-section of history as its main tool to make sense of linearity and its enlightened partner: the grid.

It's daily memories rubricated on a chromed ringtone, remembering what had happened during the last visit: a location turned to fifty pounds of sound on a butter-plank floating on frozen snapshots of wind. It violently bites plugs with calculated detachment, justifying the juxtaposition of followers and their missed rusted forks on top of a box – not any box, but a peculiar garage of obscured synonyms, known for having jacked the selective reader of high kitsch, for having inversed the low within the high, on a high. Consequently it inverts the doubling of pairs in order to push translation into analogous mode. Choose. Neglect. Theorize.

It's the stability of the pressure point, which always leads to the question, 'do you have a copy?' It's a substitute, rather, because on the side of the structure (any structure) one can always find the neglect of two combined words, whose foundation is the negation of their own recognition. Such recurrence leads sooner or later to the writing of scripts of forking strategies for the development of discourse with digital means, with a common foundation: notorious = transparency + the given once the pronouns are networked.

Confident, it begins to self-reference self-containment as safety of media saturation: confirmation is the early end of the middle of the second struggle. The blue light special did not transform the room as expected by the green activists.

$$[r]evolution == de\text{-}[re]\text{-}so\text{-}lution$$

not

$$[r]evolution = de\text{-}[si]\text{-}[re]\text{-}lution$$

Self-criticism, it evolves into meta under specialized institutions, and subsidized commodities. The result: rant all i/you/it want[s], and the consequence: citations enables the [pro]'s justification.

It reflects upon its dependence on forked papers, which changed the polyestered drama. More. FedEx the office if it finds windowlessness within favorited willowing teacups. It sense-s-[non]e, becomes hungry, and enters a[n][un] questioned state of revision; admits to missing fluidity, with the aim to make silver and wood into the will that shifts consciousness. It notices smiling breaths in search of truthful pretension: a dust remover's relation to the environment; don't miss the missing units, but instead think 'have, do, and will'.

It arrives, and quickly skips the third beat, considering it unworthy of recognition through negation; jumps half a window away from wisdom. Moving on the central threshold of the subaltern, perceives aimless movements, which have gone stale due to their swift aging in non-linear time, and whose [re]presentation is fully realized

as echo: as petitions to the RE and Frantic. It's a slow development in evolution of thought over time that contradicts efficiency in delivery; as a result, real time research is redefined. Rejection is soon repositioned as a constructive mean to build character, and its recurrence cannot be measured for the romanticized individual. It's a world in a cup that leaks damp dirt, not quite mud, while strutting with a status of delusion reversed as the virtue of the collective in the name of selfless misunderstandings of truth, only to test a new space of undefined territory.

It's tweets flowing through the drive-thru, manufactured to awaken the self from recurring amnesia, but keeping its historical conscience void. It cannot help but reminisce on memories of bold, ethical statements made to keep the purity of the mind tainted with whiteness as pure as month old snow shoveled to the side.

This is as good of a time as any to experiment with the thought process in a slow place between major cities: cover one eye with a Bacon painting, then transfer migranes as migrants of deculturized positions imposed as absolute. Meditate with [de], [re] and [ed] by trying to negate the sameness of that which is in the middle.

> *desensitized-resentionalized-destandarized*
> *recentralized-desexualized-reconceptualized*
> *decapitalized-respectacularized-demarketized*

It's the percentage of potential: consider critically nasty actions as the result of [un]pure thoughts, of serendipity standing still at the very moment of possible movement; repeat with [in]difference.

The very thought of nostalgia
fills one with the romanticized need
for improvisation as a paradigm of thought

The very thought of improvisation
fills one with nostalgia
as a romanticized paradigm of thought

The very thought of improvisation
fills one with the omission of nostalgia
as a romanticized paradigm of thought

Its redundancy validates creativity when repetition becomes too obtuse in a space no bigger than a person's frame of thought. This argument, in effect, serves as a confirmation for, to, with[in] sin of innocence in a time of full transparency, and solidifies in the mind the status of multiplicity in a flatlined period of time.

Its sedentary impulses thrive within the material space of discourse: if one only knew the purity of the unpronounced: the given... Stop. It responds to itself with a whisper, 'sanity is found in the action of empty thoughts'.

Its gaze is low to the ground; check the groove of noise destroyed by the pleasure of backend negotiations and immaterial speculations. This is nothing. Stating the obvious is the confirmation of full-fledged meandering, demonstrating what position it does not have. It's a loudspeaker.

No to the sounds of domesticated pebbles
falling against the cemented sky

No use in trying to develop coherence
Self-awareness will make bears
eating parking lots out of clouds

The validation of the left
is defined
as the center claims
alliance with the periphery

The latest demagoguery did not register in itself: instances of caffeinated fingers scraping the clouds of the mind for multiple-isms; a chronology of modular sensitivity at the center of the periphery. Eyes closed, released an empty cry – not rational, but full of sensibility; a landscape with irregular textures appeared as a reminder that true freedom is not freedom: sporadic consistency leads to thoughts of grandeur.

It's written on the walls, micro-statements worth the weight of speculation, validated as the prized pay-off of emerging markets running amok: instant gratification, usually sensed when writing aphoristic fragments for the sake of data-trends.

Once upon a time, a cloud became
the paradigm of quantification
Don't forget to sign in,
put in your time to be recognized
Expression of freedom enters a new
moment of communication when it's
primarily archived not for
reflection but trending
When your credit score is dependent on
your viral production, it will be the time
when the markets have reached an ideal moment
Been sometime since anyone
sensed the melancholy of the end
What's there to know but the trash next
to the typing tool of recyclability?
Get going with the emptiness of meaning
Live for the negative space where
to define what things are not
Heavy like cream, light like entertainment

The loudspeaker, 'ground check, sound check, bounce check against concrete'. Foam rises and levels off. The writing on the wall, 'Neighbor che'. The loudspeaker, 'Read in silence, please'. At the end of a dark alley, systems running, out-performing speculation, promising the promise of more promise; lovely to remember the lakes of lard, the sniffs of tolerance, the statement of similes, the wonder of shame, the intelligence of delusion. The loudspeaker, 'Sold out is light-fluff; disappointed the mercy-sampled song must be'. It's reminded by a sound on the other side of the street that Lalaland provides the keys made of paper and flesh to a minor systematized scale on the brink of statehood, 'not the fault, but the virtue of fault helps the self-righteous claim a voice'. Its

need for exposure with assurance demands insurance of privacy: the many faces of butter... The loudspeaker, once again, 'defer the deference of the reference byway of virality: circulation is synonymous with obsessive speculation'.

On the side-street, it's nothing but fragments: the phone of the deaf, the phone of the stream, the phone of the image materialized as noise, closely accompanied by truncated speech blurred by the speed of communication, as well as an eloquent jacking to the wooden sound of electronic waves caressing its own synthetic peach fuss. It pisses on dry leaves, the sky falls, crashing against cross-legged thoughts; Caffeinated skin rubs against the plastic reality of honesty, and feathers up its nostrils. It's not the flue, but the curls made of iron caressing the wooden sound of calamity. A whisper, 'speak it while it keeps up with its interdisciplinary obsession: looking for cotton balls in the space of magnets and flattened remotes'.

It's non-black writing on a non-white surface, pushing against a square and a circle, about half a step on top of a modem of networked experiences framed to tame reframed modularity and nonlinearity confused with random thoughts. It's nothing but the good in the blank statements made by the one fully trusted for extreme nihilism, who used to teach that undoing a previous action through subsequent inaction does not equal negation, that demented positions can be claimed only through the loss/oversimplification of self-awareness, and that rationality can only be understood through what it is not. Its common words interrupt the gaze only to become the word-cloud's main purpose of omission.

Sensitivity killing the bluntness in the cat, 'noise is the impossibility of complete control: a basic rule of culture, like gravity to nature'. But this does not register because it can only see the element of execution within the sentimentality of diffusion: objectivity's formidable enemy.

Uptown, riding on top of cotton-honey-bombs, it flows; it likes cotton. At this moment, obstructing the way a cell appears, which is no longer a statement of mobility but of immediacy, becoming the means for living the present closer to the past and the future.

On the screen, a recurring slogan, a reminder of the relation of the symbolic to material reality.

> *The greatness of plastic is that*
> *it will outlast itself as a concept.*
> *Concrete standing. No relation. Don't mind...*
> *Plastic multiplicity clears the mind.*

It observes the ongoing contention between plastic and wood which in some tertiary way resembles noise as the authority of the universal, often perceived primarily as the visual, which results in privileging seeing over hearing, and evolves into a powerful tool of demagoguery – the preferred ideology of media since its foundation in propaganda. Trending is the new form of dissemination and reconfiguration for emerging markets.

It flows on the screen, drive hard the soft wearing bits of memory resting between actions of ephemerality; never sure what the defiance of abstraction could possibly be;

such limitation gives this recurring action its power. Upon closer reflection, It conceives the unpresentable with [im]possibility of representation through representation – yet another configuration of the basic algorithm of negation as confirmation of existence.

Not late, but early in thought, it's somewhere between the two spaces of morning and noon – a place that is not quite a terrain, but rather a cluster of expressive views that constantly help redefine the network, 'the expense of the symbolic never looked better'. A statement flows through the weightless dirt, reconfigured by the train that just left the station: a user's dream relies on the illusion of objectivity. Not having a previous objective for coming to this place, which exists only for someone traveling on the threshold of morning and noon. On a screen not too far off in the woods, it becomes a void, sipping orange juice. Its task has not changed; to this day it continues to reprogram the snow so that the thought of a colder winter makes any random moment warm – designed to function as a simulacrum in the mind: the only reality in the symbolic world, which is increasingly dependent on data formations within singular nodes, as well as throughout the collective space of media gone social. It shops immaterially for inklings of notoriety.

It, itself, is the evolution of statements. It's no longer legion, but one with that which it perceives while it defines itself as many – for it knows that it is.

singular == multiplicities

It's not about flow. It is flow.

Bored to play with fat on top of a ball, it moves from right to left; plugs in to check out before too much of the terrain changes. No perception, just being. And so the time comes, and indeed it becomes the travel it performed; *it is* all things perceived. It's the statements which it tried to claim as production of itself byway of viewing the flow around itself. The space between morning and noon becomes a withering whisper. And the text flows on and off the screen, and appears everywhere.

//Declare a thing, a person, a subject position, a situation:
var Text;
//The value can be passed to other variables:
//Text becomes personal:
var I = Text;
//I becomes another:
var You = I;
//You becomes simultaneity:
var It = You;
//It becomes multiplicity:
var Spate= It;

PART V
SPATE MESSAGING

Got a Mesa, a Dorr and a Piazza this time around/
D4k is the b[u]r[r]-and in front of me/
No des-[I]-re[mix]/

Spate messaging/

Jumbo visualization is not better;
it is a rig of quantification/
The left and right respond not to each other
but to the pine-tree scent of the [un][ant]-i
season at the end of the commodity loop/
Kitchen confidence:
press here and there to go places in less than an instant/
Symbolic reconfiguration of meta-
experience leaves one empty/
Today is not a good day to do anything other than
that which is essential to the desire to feel creative/
Deceive the individual brand/
Creativity becomes [dan]ge[-ne-]rous when
it is seen as some form of escape from the
system that defines individualism/

[de]-[r][a]nged,
the celebrity looking back appeared/

The blast was too much to bear:
isotopes were plugged strategically to amend things/
Simultaneity as a concept appears to lead to
non-linear conceptualization of systems that
debunk progress as a culminating historicity/
The distance of a phone from the number to dial
cannot be conceptualized because of their [im]

material relation of action and purpose/
Rectangles and coffee cups gel/
Caffeinated thoughts: clichés for the
post drug stage of creativity/

Make a [n]-[uh]n(?) happy statement/

Trading cards,
commodities,
equities/
Fit the pattern of what the user is worth/
No need to do more than 4 traces
to know the individual...
circular thinking appears uncritical/
The reason may well be the obsession with
linearity often confused with vectors/
Loop the difference/
Obsessed with action/
Verbs are the foundation of the ideology of labor/
Systematically developed expression
appears void of human touch,
so touch it and claim it/

[h]-/gn\~ch//r\\ome. C-[on]-tract-[or]-ion[s] of [ex]~~p-[re]`'ss>>ion[s] lead [t]-[s]-he way to ef[fuc]-icci[en]cy of the K. rob[red] fried on a cookie pan~nap[ick]ed limbo filled with anthologies of rants, vents, and fana[tas]-ti-CA~ly written gossip.

The re on the fresh leads to a new set of selections that are not new on their own but on their ongoing juxtapositions/
Branding the blog of logocentrism: swift statements of
a truth turn false when the coin of signification called
ambiguity is flipped/

Wear your helmets while reading books/
Rhetorical meanderings can damage the skull/
The new recurs right now on this day, on this set/

The [n]-ew [vi]ew of the s-[l]-ame begins
to feel like a previous post.

> *One writes*
> *The same*
> *The tame*
> *The lame*
> *The fame*
> *The shame*

What happens when difference is discussed
only to enable those who define the Other to
appropriate diversity in opposition to difference?
Demagoguery appears to be the constant [re]-action to
encryption/
The drive to dislocate big data mining becomes
benign resistance when exercised from an
arm-chair while fully plugged in/
The coffee cup flipped upside down recurs/
Grande is mentioned while a biblical name
becomes a statistical recommendation/
Sig-[a]-n-[n]-ls flow on the periphery of symbolically
saturated mindless text-based communication/
Check the goods in the box/

They all read/\taste/\feel/\appear/\stink the same/

Homogeneity becomes the null resistance to the principles
of nothing/
On topic:

Resistance appears positive for critical thinking,
but one should be wary of it when it becomes
institutionalized/
Altruisms are so self-righteous/
When a critic's ego is threatened by an equal or greater,
a statement becomes a natural defense/

> *The ing always implies action*
> *Action appears productive*
> *Production appears good*
> *Good is that which is externalized:*
> *Commodities*

Feel the need to eject objects that are not foreign
but must be released for the flow of energy/
Defecate/
Someday I'm going to be more
tolerant than the chair I sit on/
Two sunglasses and a smile/
The cooling of compromise leads to nostalgia for
a time when arm chair strategy was the norm:
Cold war cooled/
Apps, jobs, ads reshape status and behavior/
This is known/
What is not known turns obvious as
soon as it's acknowledged:

> *Waning lack itself*
>
> *The organically altered red pine tree*
> *was at ease like a lost dog looking*
> *for a piece of wood; being wood, it chewed itself*

The purple plower pushed the dirt
(which was once white) to the side/
Keeping order in place turns to
the relation of Saturn and its rings/
Grande showed up (again)/
Someone's paying for that/
Not me,
not you,
not us,
but the trending industry which doesn't
mind obsessing with stats/
What could be better than to share with
friends the friends of friends/
Leave the pri of vice behind the acy/
non-value turned to value:
speculative norms defined by the zero placement/
A matter of being on the left or right;
a matter of context/
Voted best meat,
Apparently/

The plain _____ had never received a high[e\r/d] ack-w-[no]-[on]-ward-lodg[e]ment[y] What I mean is XXX... how desires comes through X#@!(* of that which one does ___ know. The state of things:1!2@3#4%6^7&8*9(0).

When typing means nothing but a formal exercise/
Find meaning in empty structures of academism/

[re]ward-[s]`~:

Adorn the minimum state of being with
oversize clothing designed for a trend to be
repeated through its own omission/

se[x]-yell//`~ing for the voice of inter-co-in-dependence/
A claim to no conflicts is their very negation/

The {[-)(n~~`!o-[i]=//s||"e" keeps coming up as
a sub[set]-jet-[lag] of critical con-[science]

> *What's there to say that does not sound nice,*
> *apathetic,*
> *critical,*
> *happy,*
> *unhappy,*
> *sarcastic,*
> *pathetic,*
> *neurotic,*
> *and pessimistic?*

The limitations of language are superseded by the constant recombination of the same/
The new is the regeneration of sameness as autonomy/
Must acknowledge the daily three/
The celebrity avatar is my favorite/
Can't help but associate the image to the principles behind the tweet/
Once the new turns into a naturalized element it no longer appears new, but proper:

New York == *newyork*
A History == *ahistory: suspension*

Keep on embellishing your statement, turning it into power hunger/
The tree is dry due to over-watering/
Compression and comprehension develop a contention when in-depth analysis takes a backseat across networks: a challenge to individualism/

I like. l[i]ke == ike - l, recommended

A critic known for adorn-o-[ing] his statements
said that the subjective and the objective
have been completely reversed/
Formal exercises are considered objective,
but they are the opposite/
Neither the subjective or objective escape politics,
both are it/
Say rock/
The connotation is specific,
even when it's made of wet feathers,
heavy due to constant heavy rain/
Hit the sack,
break your neck/

Office of [inter]\nation/~ally happen-~in[ject]gs:

The screen shows flows of communication,
movement in stasis – reconstruction to forget/
It's been a bit of a time/
Amazing how location affects what one is presented with/
To get started let's consider being creative;
what that means is the most obvious question/
Just trying to fill up the space left:
five/
Writing functions with the assumption that what is
communicated is worth sharing;
one should hope this moves beyond self-gratification/
A process can turn out to be a paradigm substituted by its
own development/
Negation confirms itself through self-resistance/
To write is to cut,
to select from a dataset/

The process of selecting to make a statement
(ambiguously) is what appears at times creative/

A statement:
a contradiction that redefines
the positive aspects of negation/
Such a statement becomes baseless upon being read/
The red in the heat is recommended
as a trend along with a 5 and its bifurcations/
One is obliged to relate the info of the brand with
the terms of privacy while eating cookies/
The monster never ate better/

Empty.;ijpoidfd;lkjae ;sd;kjf; ckj;lj; ;sdkfj a;d;kjfwor
mean[ing]-less. jkdakjli4ekd,dow[9ae./ ;; ; ;lked Got an
advanced option when kcms c` dkfidn.LJ:G<>.lLLo. Hard to
poa,me#.

Visualizing the [in]-coherent is the confirmation
of one's limitation in trying to exchange
what one knows wha.;oiuer.m,snl/
Bend the line,
make it do what physically is [im]-possible/
Writing is the economy of the ephemeral,
but not [necessarily] superfluous/
Speech to writing:
Anchored/
Materialize speech into over-cooked
visualizations clinging on to the ephemeral
[im]-materiality of speculation/
One more/
No/
The execution of the line becomes
the challenge of memory/

To remember is to erase then move from one place to
another/ A blade is mentioned for open engagement: a
sport/

After a refresh the [re] is conformed with the [mind] to
expose the local position of the subject data-mined/
Read localities for trending/
Pause,
emptiness,
[non]-activity are perceived as negative to production:
the negation of such is the
fallacy of progressive ideology/
The ambiguity of a statement is the
very challenge to its integrity:
call it art to develop resistance for
its eventual absolution/
The need for physical release produces
a tension that must culminate like most
narratives produced by Hollywood/

> *Workout*
> *Climax*
> *Defecate*

Develop the capacity to experience everything:
the swift heat of a bad cable program looking to
make elephants give birth to encyclopedias/
From dolphins to supermarkets
and artificial palm trees;
postmodernism left a thick residue/

> *Synthetic == naturalized*
> *Not anything goes but everything*

The grid is overworked and over expanded/
The beginning of the end is the beginning
of the ending of a new *new*,
not the end of a new *new*:
not the now *now*,
but just the end of the now/
Pathetic resolutions abound in the
helpless hope for a way to find help/
Stay positive when realizing that help is not in hope
but in the conflict leading to such a concept/
Almost there/

poiasdfpohweLKJB MK K K;ZLDKJ;LK
JV;Lsdfogij4k5lp9%^&*$TNHR.

pose == pray =< pay

Refresh to get a panhandle/
The closest thing to a phallic symbol as an open
engagement while kneeling for the media/

y./!``~e*%#.s+)(&.

The post is no longer past but the
lucrative statement of immediacy/
Nothing is old or new,
but recyclable within the time of recognition/
Optimization/
Got 5 on the heat Fall-[o]-ing the recommendation
of my glasses designed for clarity/
The info of the brand opens a space
for reflective commentary designed to
question innovation as truly new:
recyclability on steroids/

The archive is the means to a future
that will be recognizable,
reconfigurable:
a guaranteed experience of a new
thing that is already known/
Seagulls eating parasites bigger than ideas/
Devour the omission of a history
lived after it is produced:
death by tradition/
The [un]-challenge of meaning is its obsession with
coherence as a means to understanding the self/
Rocks become one with crabs/
Animals and things eating each other/
Binaries searching for gray areas defined by symbolic
carnivores/
Looking at the number, quality is always challenged by
the drive to quantize and quantify and potentially find
meaning in patterns of nulled movement/
Patterns reach their threshold when [un]-likes are
meaningful for open-endedness according to divergent
interests of bottom-lining/
$.

Containers fill up:
must release/
Periodic tensions acquire meaning when recognized
as corporeal and relevant to meme-capable beings/
The push for more may well be the drive to die/
The drive to live is part of a cycle: a cliché, a quantized
loop of [re]negation/
Almost there/
This is one of the last to be the first
of the middle of the end/
The then and the now become one/

And then,
there is some more time for a rhyme with the wine/
Fermentation leads to disfunction when
the user turns to constant updating/
Check the time,
try to do one last thing before the flock of
seagulls turns to more than a one hit-wonder/
Ese, ese was pronounced,
a gesture to a thing somewhere
that is currently still abstract/
The speech of location:
 a transfusion of violence/

Vio-[let]-ence. Per-[ma]-n-ence. why, [wh]-ere-[ct] the i[con]-dol to storms of stor-[e]-i//es. I-[s] there o[no]e [?]

```
//Declare a thing, a person, a subject position, a situation:
            var Text;
    //The value can be passed to other variables:
            //Text becomes personal:
                var I = Text;
            //I becomes another:
                var You = I;
            //You becomes simultaneity:
                var It = You;
            //It becomes multiplicity:
                var Spate= It;
```

:~ _ _ _ _ _ _$ exit logout

AFTERWORD
APPROPRIATING TWITTER'S COMPRESSION

Spate: A Navigational Theory of Networks is a reflection on networked communication, developed with tweets written between 2010 and 2014 on the Twitter account, @poemita.[1] The original tweets, which were written as critical commentary about online communication and information exchange were edited as five chapters titled 'parts'. The content has been repurposed and rewritten as metaphors, similes or direct literal statements from different points of view, and matched with specific terms that are representative of how individuals or groups of people may relate to each other and participate across networks.

The first part, 'Text Cluster', is a theoretical evaluation of trending, searching, flowing and messaging, the four terms with which the first, second, and third person point of view, as well as an open ended view are respectively matched in the four remaining parts. The terms are presented as an informational cluster. Part I is the least abstract of the five chapters and can be considered an introduction to the rest of the book. It begins by defining trending as an informational intensity across networks, which in effect is recognized as flowing. Search is then defined according to the flow of information. Search is also defined by the drive to communicate, which means that there is an implicit interest to eventually compose some type of message to be sent or shared. Thus messaging is the key element behind the other three, because the possibility to share information is essential to search; whatever material is found may then become relevant at a collective level by flowing and trending across networks.

[1] The project comes out of my experimentation with tweets. In 'Poem Portraits' I rewrote selected tweets as poems: http://navasse.net/poemita. I also visualized poems as interactive data projects: http://remixdata.net/2015/02/28/poemita-selected-poems-in-3d-force-layout/.

The four elements are brought together at the end of the chapter in order to show their symbiotic relation.

The second part, 'I Trend', explores trending from the first person point of view. Tweets are rewritten as personal observations that are critical of networks. This chapter, like others that follow, can be read in any order. The reader can jump in and out of paragraphs and get a sense of the overall focus; or the chapter can be read from beginning to end, at which point an abstract but specific narrative of a first person's experience of the flow of networks becomes evident.

The third part, 'You Search', focuses on search from the second person point of view. Tweets are rewritten sometimes as commands, as suggestions, or as reflective statements on what the second person may be observing, thinking or doing while searching across a network.

The fourth part, 'It Flows', presents flowing from a genderless third person point of view; not he, nor she, but 'it'. This enables the third person to appear as many things: people, places, situations, subjects, or positions. It is never clear what 'it' is. This leads to an ambiguity of the third person that in turn becomes a metaphor that shows how flow in itself is difficult to pinpoint, thus becoming an intensity that demands constant redefinition of all things one encounters.

The word spate means many things happening in quick succession. Based on this definition, the tweets in the fifth part, 'Spate Messaging', have been rewritten to read as fragments that would appear as quick texts one would read on different media of communication, but particularly

mobile devices. When read carefully the statements are closer to aphorisms and altruisms about the state of networked media and global communication. Part 5 has been organized into paragraphs that may appear more like stanzas, and there is some metric sensibility to this arrangement, though it is not a specific meter. Similarly to previous chapters, the text can be read from beginning to end or selectively. In either case, an overall reflective commentary on the aesthetics of sending and receiving messages becomes evident.

The relationship of the terms and points of view for each part are emphasized with basic computer programming variables on preceding pages. The first variable declared is 'Text'.

> //Declare a thing, a person, a subject position, a situation:
> var Text;

'Text' becomes executed as a program, metaphorically speaking, in the actual part that follows, titled 'Text Cluster'. Consequently the value is passed on from text to the variables I, you, it, and spate, in the pages preceding each of the following parts. The declarations of variables point to the abstract narrative that can be experienced if the parts are read in sequential order. The basic lines of code are designed to emphasize how all of the content in essence is interchangeable, malleable, and always open to redefinition based on how one may decide to take on a specific point of view to make sense of things.

The content in *Spate* could not have been written without the compression of information at play across networks at the time of this writing. Twitter is unique in this sense.

It encapsulates a technological trend that has been taking shape since the rise of online networks, particularly in social media. The reason why online communities across the world have been able to thrive is, in part, due to the relentless drive to create and optimize the archiving and accessing of meta-data about information that may be relevant for diverse interests ranging from in-depth research by scholars, artists and designers to careful analysis of trends for marketing by corporations. Twitter in a way is a node that well exposes how compression is crucial to the ongoing optimization of cultural and commercial production. The social media site is a mashup of material that in the past was not always deemed directly profitable, but with the rise of data-mining, new ways for monetizing the analysis of archives of what once may have appeared to be innocent or banal activities have become crucial for the expansion of emerging markets.

As I evaluated the tweets I posted on @poemita, I began to consider new ways of repurposing the material. Part of this experimentation included poems. I also wrote a couple of short stories, which remain unpublished at the time of this writing. Through much experimentation, it was the form that tweets from 2010 to 2014 took as an eventual book of five chapters that, in effect, is part theory and part art that appeared to me to be the right format for reflection on the flow of information across social media platforms, such as Twitter.

When I decided to use the tweets to develop some sort of lengthy narrative, initially I created a genderless fictional character for which I wrote a short story using posts from the years 2010-2011. I also considered presenting all of the tweets as a single long paragraph that would flow across

several pages. Initially, the tweets in the early version of the book were in chronological order, and were very much left intact, but as I developed the concept of having different points of view for each part, I began to move material across all chapters. As I played with the content it became evident to me, as I also received feedback on the project, that such approach still did not live up to what I was trying to accomplish. Later, I wrote a more extensive version of the initial story, which eventually became part 3, 'It Flows', of the current version, which originally was the first part of the book. And the last part of the early version eventually became the first part in the current version. If one were to compare the material in *Spate* with the actual tweets from 2010 to 2014, one would find that much content has been added and deleted in order to develop an argument – one which at first may appear abstract, but with careful examination, a criticism of social media and the flow of networks emerges in the form of art. In terms of remix, *Spate* uses principles of selectivity to function as a reflexive remix; it attains autonomy, becoming something else beyond the original tweets, but it still needs to have a clear connection to Twitter in order to develop its critical position on social media.

Spate brings together my interest in art, literature, and critical theory. And for this reason, I consider it to be a form of theoretical fiction. In effect, the five chapters function as an anti-story about multiple perceptions within a decentralized network. I consider *Spate: A Navigational Theory of Networks* to be a reflection and commentary on contemporary reality, produced within, but critical of the ways technology is defining individuals as subjects in relation to collective communication.

Eduardo Navas, September 2016